Creative Colored Pencil
PORTRAITS

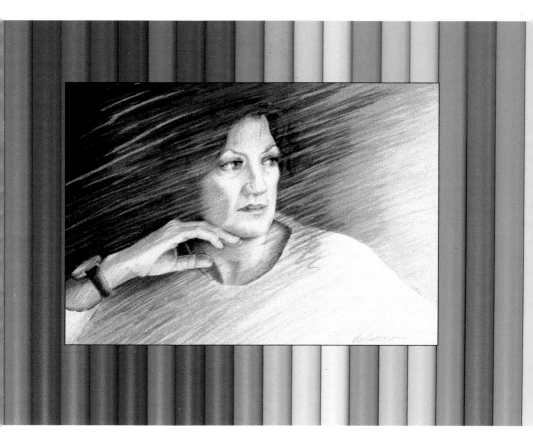

QUARRY BOOKS
Rockport, Massachusetts
Distributed by North Light Books, Cincinnati, Ohio

First published in the United States of America by:
Quarry Books, an imprint of
Rockport Publishers, Inc.
146 Granite Street
Rockport, Massachusetts 01966-1299
Telephone: (508) 546-9590
Fax: (508) 546-7141

Distributed to the book trade and art trade
in the United States by:
North Light, an imprint of
F & W Publications
1507 Dana Avenue
Cincinnati, Ohio 45207
Telephone: (513) 531-2222

Other Distribution by:
Rockport Publishers
Rockport, Massachusetts 01966-1299

ISBN 1-56496-265-2

10 9 8 7 6 5 4 3 2 1

Art Director: Lynne Havighurst
Designer: Laura Herrmann Design
Editor: Shawna Mullen
Cover: *Self-Portrait* by Vera Curnow
12" x 15" (30 x 38 cm)
Cover Photography: Douglas Cannon

Manufactured in Hong Kong by Excel Printing

To My Son
MARK G. CURNOW
With Unconditional Love

ACKNOWLEDGEMENTS

PHOTOGRAPHY:

Joseph Kirkish
Joseph Kirkish Photography, Houghton, Michigan

Gregg Harpin
G&H Photography, Houghton, Michigan

Tod Gangler, Joe Mentele, Dave Tannahill
Duck Island Limited, Seattle, Washington

PROFESSIONAL COURTESIES. . .

The Many Artists Who Graciously Contributed

Rosalie Grattaroti, Shawna Mullen, The Pod, and the
Production Staff at Rockport Publishers

WITH A LITTLE HELP FROM MY FRIENDS. . .

Meredith Luhrs
Monica Kent
Incha Lee
Mary Ann Beckwith
Bill Curnow
Sharon Wayson

TABLE OF CONTENTS

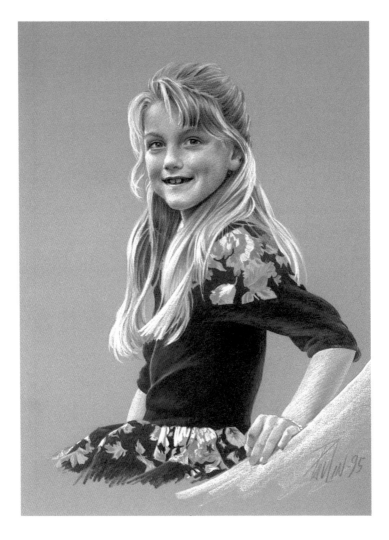

JESSICA

16 x 20 in (41 x 51 cm)

Bernard Poulin

FOREWORD

Bernard Aime Poulin

A t a recent art exhibition I was introduced to several young people celebrating the opening of a fine art school's group show. I was forced to ignore a snicker of "Oh yeah… the old portrait artiste" as I shook hands all around. I knew then it wouldn't be long before the venerable art of portraiture would be challenged and the "old fogey's" armor chinked.

At one point, during a particularly lively discussion on portraiture (in which my participation had not yet been considered), I was suddenly asked whether the ability to achieve an absolute physical likeness was an accurate measure of a good portrait artist. The questioner was either a self-obsessed art afficionado or a young "art pup" out to prove he wasn't intimidated by the old man in the crowd. The nervous nail-biting convinced me of the latter.

After a suitably dramatic moment of reflection, I countered by saying: "The greatest pleasure derived from unveiling a portrait is seeing a client silently smile acceptance or hearing them say, 'Oh, how you've captured him.' or simply whisper, 'It's her!' On the other hand, my greatest fear has always been that a client would not see anything beyond an achieved likeness."

The importance of a symbiotic connection between a work of art and a viewer did not seem to impress the assembled—so, I was pressed to elaborate, be more direct, more academic. The following is a summary of my answer and general feelings regarding contemporary portraiture:

When the sum total of a portrait artist's talent is based on his/her ability to accurately render a subject's likeness, the whole exercise gets bogged down in the craziness of analytical process. "Critical analysis" is akin to dissection and autopsy—these are impossible unless you have, beforehand, accepted to destroy the subject. The technical aspect of painting a portrait should have been assimilated long before the actual acceptance of a portrait commission. In this way, this process does not interfere with the intensity of the task at hand. To paint a portrait is to be fascinated, amazed and even dazed by the incredibleness of the abstract human spirit, as it is embodied in the intricate, sensuous physicality God has given us. In the final analysis, portraiture is the most passionate and frightening of all artistic exercises. It dares to search for the self in others and others in the self.

This book will introduce you to Vera Curnow's work, her collaborations, her writing…her love of the portrait. Vera displays this passion of which I speak. She knows of the humour and pathos which harmoniously interplay in the power of human expression. That knowledge is only visible in the work of the truly talented.

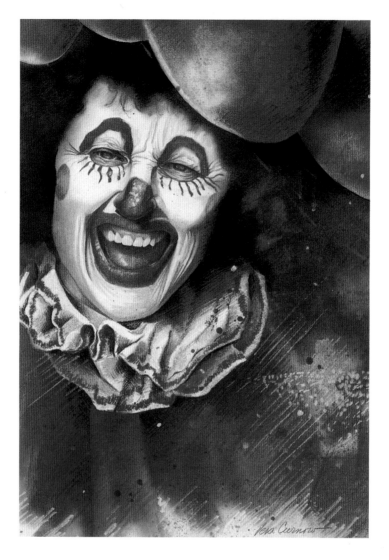

PATTI GREEN

30 x 20 in (76 x 51 cm)

Vera Curnow

INTRODUCTION

Vera Curnow

"Portrait painting is certainly not on its death-bed, but (...) far more rarely practiced than it used to be."

Jakob Burdckhardt 1885

Did you know Leonardo da Vinci actually dissected and dismembered cadavers for the sake of art? Studying pathological anatomy gave him, and other portraitists, a physical understanding of the human internal structure.

The good news is that this book does not take that direction. You won't find any anatomical studies on abdominal viscera within these pages. I'm not even going to tell you that the upper lip has three muscles and the lower lip has two or that the pupil is aligned with the corner of the mouth.

While an understanding of anatomical facts is invaluable for graphic interpretations, I don't believe you have to become a doctor to practice art. You don't really need to understand the nerve distribution of the human body to be able to draw a nervous person.

In fact, and I am opening a hornet's nest here, my suggestion is to stop measuring the distance between freckles. In making a portrait you are not calibrating the blueprint of a diesel engine. This is Grandma Mildred's face. Instead, try interpreting the model as a heartbeat full of opinions, emotions, and character within a figural mass of shape, value, texture and color.

Yes, certainly strive for accuracy but not at the exclusion of artistic integrity. Experiment with creative lighting, different poses, abstract backgrounds, a new palette, surface, or technique. If you're using the same "formula," give it a rest—your work is becoming predictable.

The operative word in the title of this book is creative. This book gives you permission to make mistakes, be outrageous, use neon colors and burnish with a golf tee. To the extent possible, the pencil colors are listed in the order that the colors are used. The artists in this book show you how to do this and still produce creative portraits. Don't just dissect their methods, try putting them to work for you.

CREATIVE INTERPRETATIONS

"It looks just like her!"

This statement, meant as a compliment, is probably the first response that portraitists hear. However, unlike a character study, "looking just like her" is a given expectation in commissioned artwork. After all portraiture is primarily a commemoration of the sitter's appearance. But then, so is a photograph. So why should people pay you to do in weeks what a camera can accomplish in a flash? We all know the answer. It's that you, as an artist, can interpret and express what a camera can not create—or any other artist for that matter. Working directly from a model, however, is not always possible or practical. That's when photographs become a useful reference tool. It's important to remember that they are not the finished product. Reference materials should be just that—a starting point from which to emphasize, enhance, embellish, and interpret.

There has always been a genre of beginning artists who do little more than duplicate a photograph. Artists who copy each pore faithfully and unquestioningly are always surprised when their entry to a juried competition is rejected. After all, "it looks just like her." They don't realize that *an accurate portrayal does not necessarily equate to good art.* It must also have artistic merit. This is what separates artists from technicians.

3

1

2

4

One Model, Six Artists

While the subject's likeness is certainly identifiable, the result is usually an uninspired human landscape frozen in the center of the page. As nationally recognized artist Alex Powers so aptly put it, "a successful portrait is first of all a successful painting."

Don't misunderstand. Rendering the client's likeness is essential, and it demands practiced draftsmanship skills. If stately Aunt Martha suddenly looks short, fat and a little like Quasimodo, don't expect to get paid. Accuracy is important; but, as artists, we owe our customers more than a redundant colored pencil reproduction of a photograph. While a single negative can reproduce the same image over and over again; in art, an image should have as many variations and definitions as the number of artists depicting it.

The six artists featured in this section have been asked to demonstrate their creative interpretation of the same model. Each artist was given an identical set of eight photographs, and the option of working from one photograph or making a composite using two or more. They were given only one rule: "Feel free to break any rules." Since these artists are from various parts of the country and have never met the "client," they were instructed to make certain assumptions:

A. money is no object,

B. the client knows art and is a sculptor

C. she appreciates all artistic styles— classical to contemporary, and

D. the painting is for her home.

By comparing the individual styles and variations— from composition, background, color mood, technique, etc.— you will see the many creative decisions artists make in taking the colored pencil portrait beyond the lens and into the world of art.

5

6

7

8

DRY PIGMENT, WET LOOK: Keeping Solvent

Vera Curnow

D rip, stain, smudge, smear, and splatter, these words probably make you think of water-soluble pencils. Think again. This vocabulary also applies to waxed-based colored pencils. Ten years ago, as an alternative to conventional methods, I discovered that solvent mixed with dry pigment produces effects contrary to the medium's expectations. In the midst of my wild artistic abandon, it occurred to me that this mixture had a name: by dispersing the dry pigment into a liquid vehicle I had created—drum roll, please—paint!

So, why not just use paint? Unlike watercolor, oil, and acrylic—or even water-soluble pencils—the turpentine/pigment mixture has its own unique appearance, capabilities and applications. It is less fluid than watercolor; less viscous than oil. As with watercolor, I can encourage surprises, work spontaneously, create a fluid look and achieve the same transparency. However, with turpentine and pigment I can also quickly create dense colors—an advantage over watercolor. Unlike dry layering, this mixture eliminates the white glint of the paper with a sweep of the hand and covers a large area in less time.

Using the solvent-mixed pigment is a refreshing alternative. And I like the results. This painterly look is actually a combination of wet and dry methods. *Incha's Scarf* was my first portrait using this wet technique. I share this to encourage you to experiment with the medium, explore new subjects and challenge your abilities—if I can do it for a book, you can do it for yourself.

◄ *Reference Photograph No. 3. The model's pose and wistful direct gaze are captivating. By eliminating her surroundings, the viewer is given less information—and more latitude for interpretation.*

PALETTE

HAIR

- Raw Umber
- Indigo
- Tuscan Red
- Periwinkle
- Raspberry
- Dark Purple

SKIN

- White
- Peach
- Orange
- Pink
- Salmon
- Copenhagen Blue
- Hot Pink
- Metallic Maroon
- Scarlet
- Lavender
- Greyed Lavender
- Blue Violet
- Violet
- Periwinkle
- Aqua
- Light Blue
- Mediterranean Blue
- Chartreuse

EYES

- Violet
- Indigo
- Tuscan Red
- Light Blue
- Scarlet

SURFACE

Crescent Cold Press
Illustration Board

SUPPLIES

Wax-based Colored
 Pencils
Colored Art Sticks
Odorless Mineral
 Spirits
Electric Sharpener
Electric Eraser
Kneaded Eraser
Sandpaper
Bristle Brushes Nos.
 1, 2, 3
Cotton Swabs
White Cotton Rags

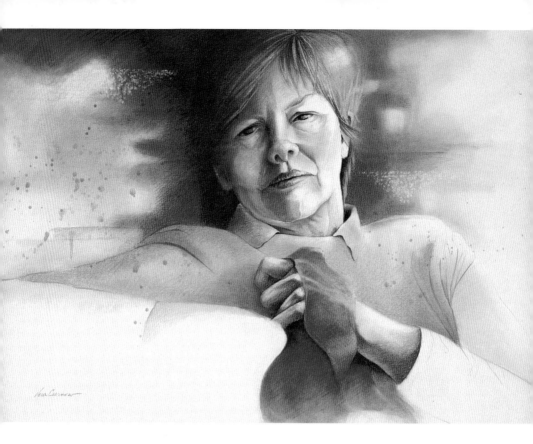

INCHA'S SCARF

28 x 40 in (71 x 102 cm)

Vera Curnow

Rather than a tight rendering, this painting was
approached from a design standpoint working in two- and
three-dimensional space. The vignetted lower portion and
other negative spaces keep the center of interest in a vertical
format within this horizontal composition—the scarf, which
was added for personal reasons, is an essential component.

▶ *The juxtaposition of colors and values, more than lines, are used for modeling. The subject's fair complexion is abstracted with non-traditional colors that tend to exaggerate her facial features. Lost edges blend the hair into the background. Dry pencil strokes are sometimes added over the turpentine-pigment mixture and left visible.*

◀ *Light values on the face are the paper's surface, while the white stippled-effect in the background is done with an electric eraser. This is an indispensable tool (and drawing implement) when working with this technique.*

▶ *Rubbing an art stick on coarse sandpaper leaves a concentration of loose pigment. This can be lifted with a turpentine-soaked stiff brush to create surface drips and splatters. The red and pink areas are spread with a rag—the yellow strip was applied with a brush.*

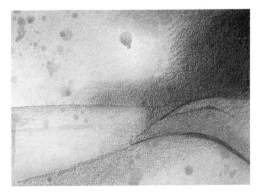

FAST TECHNIQUES: It's About Time

Thomas M. Thayer, Jr.

H ow long does it take you to do that? While some artists can answer this frequently asked question by looking at a clock, others must refer to their calendar. Tom Thayer is one of those rare colored pencil artists who can "crank out" professional results in relatively little time. It has only taken him twenty years to be able to do so.

Saving time, however, is not the point. When it comes to art, Tom is obsessed with being prolific—although not at the expense of quality. He slowly developed his fast style by first learning how to draw everything in the picture. It was only then that he progressed to learning what details not to draw. By selectively omitting extraneous information, Tom *insinuates* detail—making the mind's eye see what is not there. He uses color sparingly and lets the surface of the paper add to the illusion.

Using paper that is the same color as the majority of the drawing certainly speeds up the process. But that's just an added benefit. Tom's choice of black mat board changes this ordinary domestic setting into a dramatic scenario. The black surface, coupled with Tom's abstract rendering of the background, adds an aura of mystery and intrigue. The curtains, loosely implied, suggest wings. The detailed outdoor background has been eliminated, leaving only the white flecks needed to balance the composition. Beyond capturing the model's likeness, Tom's interpretation of a "nice" photograph becomes a compelling work of art. *Angel of Winter* was completed in six hours.

PALETTE

HAIR

No color was added to the black mat board

SKIN

Burnt Ochre

Peach

Light Peach

Raw Umber

White

EYES

 Warm Grey 50%

Raw Umber

White

Light Blue

Scarlet

SURFACE

Crescent Acid-Free Black Mat Board Smooth Finish

SUPPLIES

Wax-based Colored Pencils
Colored Art Sticks
Water-soluble Colored Pencils
Pencil Sharpener
Workable Fixative

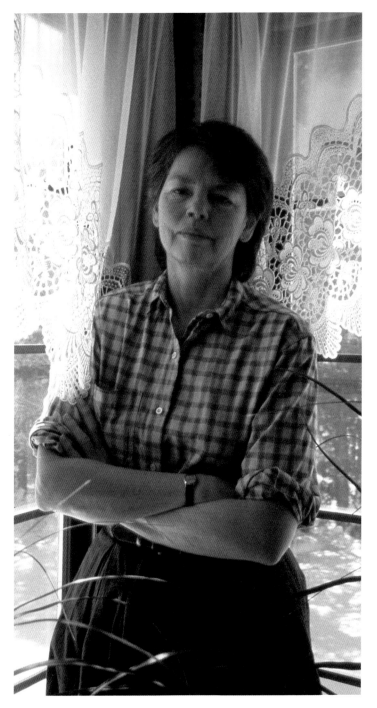

◄ Reference Photograph No. 2. The artist responded to the warmth of the model's face surrounded by the suspended animation of the cold winter. While some portraitists frown on using a double light source, the light streaming in from the south and west windows created a central shadow that makes the model luminous.

ANGEL OF WINTER

20 x 16 in (51 x 41 cm)

Thomas M. Thayer, Jr.

The darkest values in this painting are the untouched surface of the black paper showing through—note the hair and clothing. Curtains become wings and accent the model's face. Outdoor detail is reduced to abstract shapes to support the theme and balance the composition.

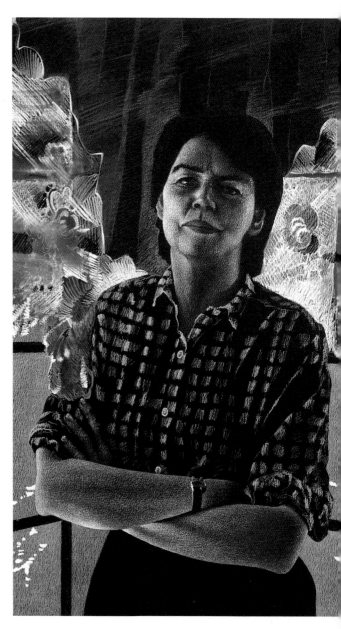

▶ *A peach-colored pencil is used first to make the middle value. Light and dark values are created alternately as the work progresses. The value ranges are established by layering single colors—rather than using a different color with a darker value. The goal is to get the maximum effect with the fewest possible color changes. The pupil and iris in the shadow area are merely implied with the use of white highlights.*

◀ *Only two colors were used to suggest the shirt. Loosely applied pencil strokes create the pattern—leaving the surface of the paper to define the fabric folds. This saves time, and, more importantly, gives texture to the fabric and integrates the subject with the background.*

▶ *Distinct strokes of wax-based pencil were combined with blended water-soluble pencils to create the gossamer look of the "wings," which adds energy and movement to the otherwise stationary solidity of the model. This would have been an entirely different painting if the curtains had been tightly rendered.*

CIRCULAR APPROACH: A Value Judgment

Maggie Toole

R andom and spontaneous—but not unstructured. With the instinct of a spider spinning a web, Maggie Toole weaves intertwining circles into delicately balanced portraits. This paradox of working in the abstract to create representational subjects is a perfect example of synergism— the circles, in and of themselves, are only empowered in their mass. And what appears to be a haphazard approach is actually an analytical process.

It begins with a scaleograph. Maggie relies on this tool to crop and change the proportions of her reference photograph. Once she decides on the composition, she lays the scaleograph over white paper and traces the outer dimensions. The resulting rectangle is then cut to leave an opening. This creates a paper frame

which is placed over the image along with a sheet of clear acetate. Maggie draws a grid on the acetate then uses a proportion scale to enlarge it onto her drawing surface. This is the only time she will use lines in her work.

Guided by an internal vision of their purpose, she begins drawing circles over the grid— highlight areas first and then the shadows. Randomly moving from one section to another and using extremely light pressure, she takes care not to fill the tooth of the paper too soon. This allows her to make adjustments during the early stages. Maggie continues to bring up the highlights and deepen the shadows until the disjointed circles become a cohesive mass of volume and form. *Reflecting…is an* excellent study of the use of value patterns to create images.

▶ *Reference Photograph No. 4. The artist crops into the photograph to focus on the model's pensive mood. The light colored, wrinkled shirt poses an interesting challenge using this technique.*

◄ *A proportion scale and scaleograph were used to transfer the grid to the drawing surface.*

PALETTE

HAIR

Blue Grey

Olive Green

Mahogany Red

Marine Green

Copper Beech

Peacock Blue

Grape

Tuscan Red

Burnt Ochre

Madder
Carmine

Red Brown

SKIN

Raw Sienna

Pumpkin
Orange

Olive Green

Pale
Vermillion

Rose Salmon

Rosy Beige

Burnt Yellow
Ochre

Burnt Ochre

Light Violet

Red Violet
Lake

Terra Cotta

Copper Beech

Peach

Grey Green

Van Dyke
Brown

EYES

Blue Grey

Mahogany Red

Red Violet
Lake

Light Violet

Marine Green

Tuscan Red

SURFACE

Canson Mi-Teintes
 Burgundy #503

SUPPLIES

Wax-based Colored
 Pencils
Kneaded Eraser
Electric Sharpener
Proportion Scale
Scaleograph

REFLECTING...

30 x 22 in (76 x 56 cm)

Maggie Toole

Circles are just the vehicle used to lay down pigment. The real focus of this technique is on defining value patterns to create form. No contour drawing is made of the image. The composition is mapped out by loosely plotting the light, then the dark, and, finally, the middle values.

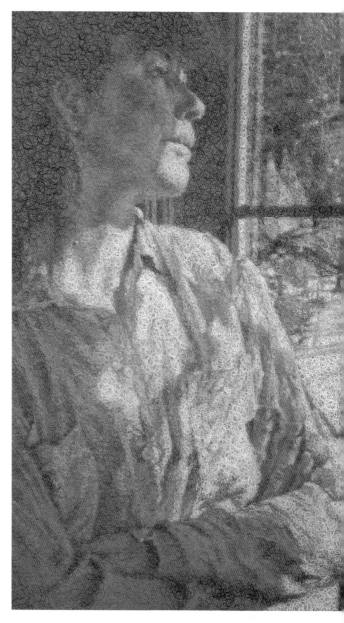

► Very light pressure is used in the beginning. Areas that will end up nearly white begin as circles of raw sienna. Shadow areas begin as blue grey and olive. High-contrast values are built up gradually, to keep them balanced.

◄ Circles are overlapped. Varying sizes are randomly drawn. The same colors, used in different proportions, are placed in all areas of the work. Changing colors frequently is important.

► This detail of the window shows the model's reflection over the trees. The many color layers mix and blend to visually define the shapes Pencil pressure becomes increasingly firmer as the work progresses.

BURNISHING EFFECTS: Without the Pressure

Sheri Lynn Boyer Doty

Master artist Delacroix worked with a palette of twenty-three colors; Rembrandt used only six. But who's counting. Art, after all, isn't judged by the process but by the end result. So, whatever it takes to produce the effect you want is the "right" thing to do—generally speaking. But, there are exceptions. For Sheri Lynn Boyer Doty, the exception is heavy pencil burnishing. Although it produces wonderful effects,

Sheri deliberately avoids this technique in her commissioned work.

In portraiture, it is important to be able to make adjustments or changes at the client's request. While colored pencil burnishing is an effective method to blend hues, create reflective surfaces, produce rich dense colors and obliterate the glare of the paper, it is not conducive to making changes. The slick wax coating that heavy burnishing creates makes it difficult to introduce new layers of color or make even subtle adjustments: A definite disadvantage in commissioned portraits.

Sheri keeps the painting workable until the final client approval by working selective areas just to "the edge of burnishing." Should the surface become too glossy for additional pigment, she sprays a fine mist of fixative to create more texture. Sheri uses colorless markers, which are filled with a clear solvent, to enliven very dark shadows and to help eliminate the white "valleys" of the paper. To blend colors, she intersperses the colorless markers between several layers of colored pencil. Lighter blending is done with a stump. Both methods allow Sheri to alter the work or to add more pigment.

Sheri's use of strong colors and value contrasts makes a riveting statement. By placing the lone figure on an empty train, *Transfer to Flinder Street Station* leaves us intrigued, with more questions than answers.

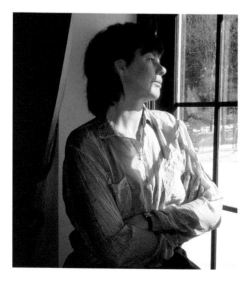

◄ *Reference Photograph No. 4. The artist sensed emotional movement— a period of transition— in the physical stillness of the figure.*

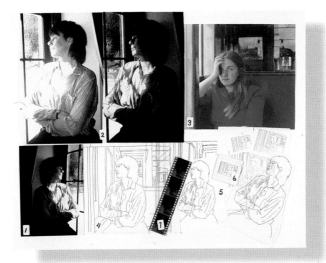

◄ An overexposed print of the original photo revealed details in the shadow areas; a dark print exposed those in the light. Other references: Photo and negatives of the train interior, combined sketches of train and model, photocopies of sketches reduced to fit into a slide mount for projecting.

PALETTE

HAIR

- Dark Umber
- Burnt Ochre
- Black
- Peach
- Beige
- Light Umber
- Sienna Brown
- Sepia Light Umber

SKIN

- Sepia
- Dark Umber

- Black
- Mahogany
- Raspberry
- Tuscan Red
- Vermillion
- Peach
- Light Peach
- Carmine Red
- Grape
- Rosy Beige
- Clay Rose
- Sienna Brown
- Terra Cotta

- Blush
- Crimson Lake
- Salmon Pink
- Light Pink

EYES

- Black
- Dark Umber
- Light Umber
- French Grey 50%
- French Grey 90%
- French Grey 10%
- Dark Brown

SURFACE

Strathmore 500
 Bristol 3-Ply
 Vellum Surface

SUPPLIES

Wax-based Colored
 Pencils
Pink Pearl Eraser
Colorless Blender
Stump
Artist Knife
Electric & Handheld
 Sharpeners
Mat Fixative

- Beige
- White
- Light Peach
- Peach

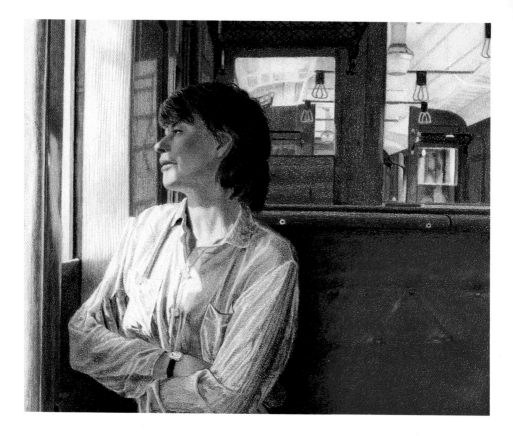

TRANSFER TO FLINDER STREET STATION

11 x 12 in (28 x 30 cm)

Sheri Lynn Boyer Doty

The off-center composition is a vital factor in this visual narrative. The artist wanted to convey a transitional time of self-doubt and anticipation. A centered portrait would create a feeling of stability and ownership of the space. The model's pensive gaze evokes thoughts of the past or the future rather than any sense of the present.

► *Several color layers are applied to the hair and then blended with a colorless marker—the sequence is repeated two more times, ending with the marker. Highlights are created last by scraping fine streaks with an artist's knife. Sepia and light umber are applied to these areas.*

◄ *Notice the distinct range of values. The sun-struck areas of the neck and blouse are captured with heavy layers of opaque white, middle values show the transparency of the fabric, and black is used in the deepest shadows.*

► *The expanse of the dark blue seat is blended and deepened with a colorless marker; black is added to the shadow areas.*

ONE HUNDRED PERCENT RAG: Working on Fabric

Sory Marocchi

Recurring shapes. Repetitive colors. Ambiguous spaces. And then—a jolt of recognition. You see a face. It emerges from the chaotic rhythm of this colorful mosaic. Undaunted by strong colors and complicated designs, Sory Marocchi fearlessly incorporates a portrait into an unlikely environment. While most of us anguish over which white paper to work "on," Sory chooses which printed fabric to work "in."

When printed fabric is used as a painting surface, it is more than just a support to hold the pigment; it becomes part of the medium used to create the art. Choosing fabric is unlike choosing paper, since there is more to consider than just the textural aspects of the material. Sory also considers the relevance of the cloth's design to her subject, the flow and repetition of the shapes in the pattern, and the pattern's color scheme and values.

Visualizing the pattern as three-dimensional, Sory determines how to integrate her subject matter with the design of the fabric. The changing value patterns dictate the positive-negative reversals needed to lay down color—dark pencils on light background and light on dark. These cognitive value shifts, between the geometric shapes of the fabric and the shape of the model, give the illusion of mass and volume.

Each new fabric provides a different environment and demands a fresh approach. Artistically inspiring, mentally challenging—the process is as varied as the results—and the possibilities are endless.

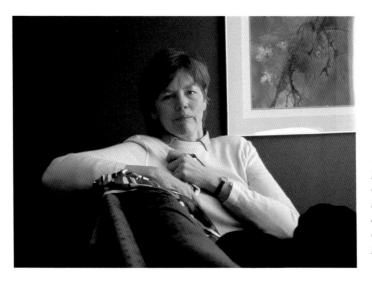

◀ *Reference Photograph No. 3. This straight-on view showing the model's head and shoulders is a pose that the artist commonly uses on her patterned ground.*

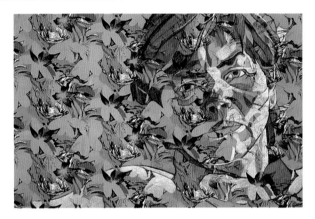

◄ *Each fabric selection demands its own interpretation. In* Light II *(at left) and* Light III *(below), notice how the change of color and printed pattern affects the end result.*

PALETTE

HAIR

Black

Violet

Mulberry

Goldenrod

White

SKIN

Goldenrod

Peacock Blue

Marine Green

Black

Violet

White

EYES

White

Peacock Blue

Black

SURFACE

Light I - Polyester Blend Fabric

SUPPLIES

Wax-based Colored
 Pencils
Kneaded Eraser
Manual-crank Pencil
 Sharpener
Rhoplex Spray
 (Sizing)
Workable Fixative

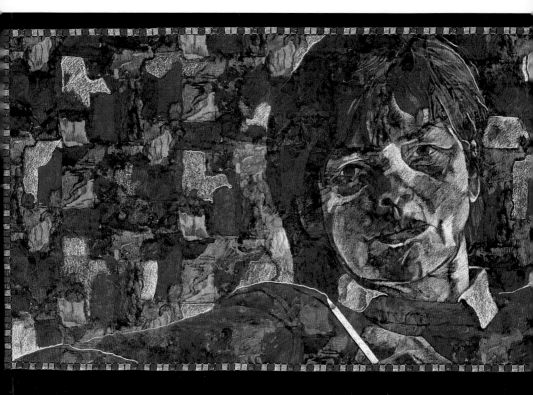

LIGHT I

24 x 40 in (61 x 102 cm)

Sory Marocchi

Almost surreal in this environment, the subject emerges from a
labyrinth of richly colored patterns. The model's gaze, coupled
with the stained-glass quality of the fabric, reminded the artist
of the quiet reverence one feels in an empty, sunlit church.

► Sizing, lightly sprayed on the fabric to make it more receptive to colored pencil, stiffens the material and fills the pores of the weave. The translucent quality of colored pencil allows the pattern of the fabric to show through the applied pigment.

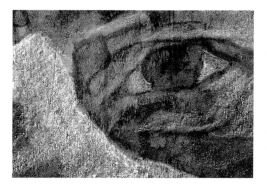

◄ The subject is carefully drawn to become part of the fabric's pattern. Light and dark values of colored pencil, combined with those woven in the design of the fabric, are used to define spatial relationships. Strokes are applied loosely and left visible.

► The printed design dictated the palette of this painting. A detail of the model's hair shows how traditional colors are effectively replaced by those of the fabric.

COLORED MAT BOARD: Watch Your Tone

Amy V. Lindenberger

The most important color in Amy Lindenberger's portraits doesn't come from pencils. No, it is the paper itself that holds the most influential color. Whether stark white, mat black, or any of the full spectrum of colors in-between, this solid tonal mass serves as the value foundation for the artwork. And, it sets the mood.

It is no surprise that colored pencil hues, and their intensity, change with different colored surfaces. When paper and pencil are of the same value (light on light), the color appears to recede: Contrasting values of paper and pencil (light on dark) make color appear to advance. For this portrait, Amy chooses a middle-value board that allows her to work from the lightest highlights to the deepest shadows.

While the grey-violet colored paper serves as the mauve undertone Amy sees in the skin tones, she must also consider the affect this color will make on the other areas. Because of its overall influence, the color of the mat board also dictates her palette selection. Using the color of the surface as a unifier, Amy limits her palette. Here, the primary color scheme consists of four analogous colors: blue, blue-violet, violet, and red-violet, along with their complements of orange and yellow-orange.

The division of light and shadow in *Out of Reach* emphasizes the dramatic scene Amy has created. The addition of another figure interacting with the subject goes beyond portraiture to become an illustrative narration. By animating a simple gesture, Amy takes the model from a passive state to an active one—rife with visual dialogue.

PALETTE

HAIR
- Terra Cotta
- True Blue
- Black Grape
- Goldenrod

SKIN
- Terra Cotta
- Black Grape
- Peach
- Light Peach
- White

- Imperial Violet
- Henna
- Blush Pink
- Non-Photo Blue
- Periwinkle

EYES
- Non-Photo Blue
- Deco Blue
- White
- Slate Grey
- Warm Grey 90%

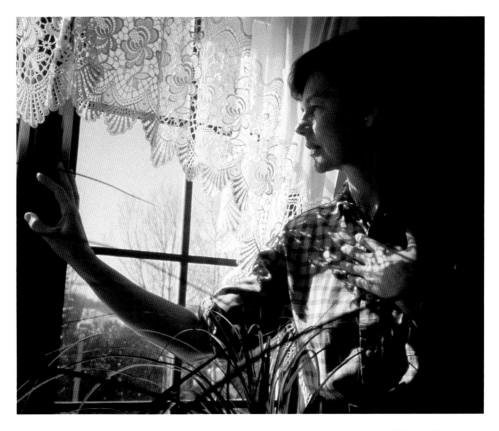

SURFACE

Crescent 100% Rag
 Mat Board #1595
 Grey Violet

SUPPLIES

Wax-based Colored
 Pencils
Kneaded Eraser
UniTouchMatic
 White Plastic
 Eraser
Electric Eraser
Workable Fixative
Opaque Projector

▲ *Reference Photograph No. 1. The play of light and shadow, coupled with the model's expression, intrigued the artist. The green plant and model's watch were eliminated. Wall space to the right was reduced and the curtain's edge was moved so it no longer intersected with the head. A second figure was added.*

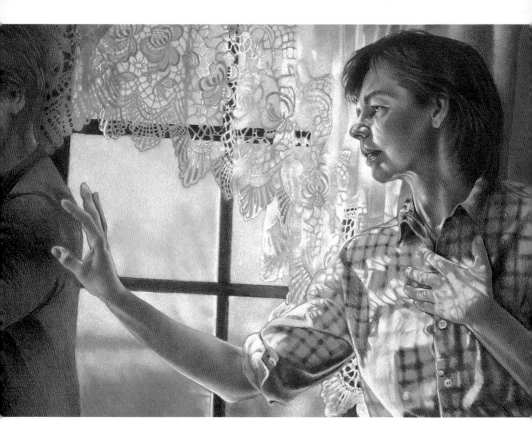

OUT OF REACH

13 x 19 in (33 x 48 cm)

Amy V. Lindenberger

The grey-violet mat board serves as the mid-tone for the portrait.
Lighter areas are created with a gradual progression of values within
a color's spectrum (i.e., true blue, non-photo blue, deco blue, etc.).
A limited palette is chosen to complement the grey-violet
drawing surface.

▶ The highlights in the hair are made by removing streaks of color with a white plastic eraser and then inserting a lighter color in the erased line. The darkest areas of the hair are a blend of black grape and terra cotta; highlights are inlaid with goldenrod.

◀ The brightest highlights of the skin are warmed with yellow orange; areas that appear pink are a combination of peach, pale vermillion, and yellow orange. Gradual color and value transitions are made with a fine-line hatching stroke. Cross-hatching is used in larger tonal areas.

▶ The color of the paper serves as the base for the dark-est values in the white curtain. This also helps to define the intricate lace pattern and add interest to this dominant area.

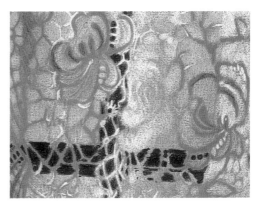

SIX INTERPRETATIONS:

Comparing the Results

Here's how the artists in this section expressed their vision of the model. Notice that each of them captured her likeness while leaving their own distinct imprint of style and technique. Had all six artists reproduced the reference photographs in exact detail, color and composition, then five of the artists would have been redundant—and unnecessary. Unlike most fields of study, the structural rules in art are merely a springboard. It's the unique presentation of the same subject that keeps art alive and vital and challenging.

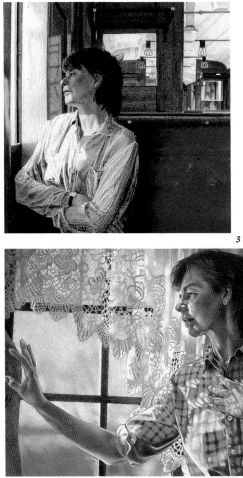

1

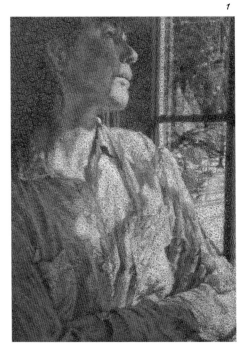

2

3

1 **REFLECTING ...**
 30 x 22 in (76 x 56 cm)
 Maggie Toole

2 **TRANSFER TO FLINDER STREET STATION**
 11 x 12 in (28 x 30 cm)
 Sheri Lynn Boyer Doty

3 **OUT OF REACH**
 13 x 19 in (33 x 48 cm)
 Amy V. Lindenberger

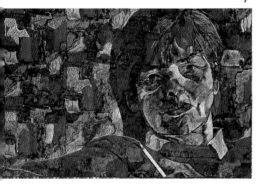

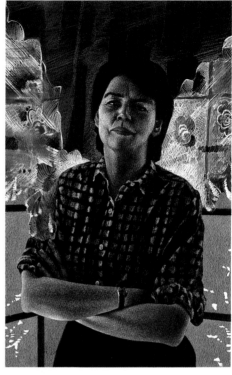

4 **LIGHT I**
 24 x 40 in (61 x 102 cm)
 Sory Marocchi

5 **ANGEL OF WINTER**
 20 x 16 in (51 x 41 cm)
 Thomas M. Thayer, Jr.

6 **INCHA'S SCARF**
 28 x 40 in (71 x 102 cm)
 Vera Curnow

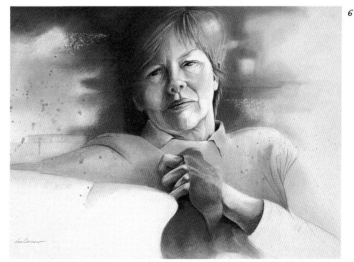

THAT FACE IN THE MIRROR

Remember when we were children—pink, brown, red, and yellow pretty much did the job for painting people. As artists, while we may have our favorite palettes, we know there is no magic formula for creating flesh tones. How boring it would be if there were. Aside from the complexity of various races, and the tonal variations within these races, skin is also influenced by ambient light and colors. It is the difference between the way you look in the sunlight or under fluorescent lighting—or when wearing a red sweater versus a green one. For portraits, the magic occurs in skin tones when unexpected glints of non-traditional hues are used to energize and define facial planes and to create a mood. A touch of magenta, a flash of yellow, or a dab of ultramarine adds spark to a dark complexion. And a dash of turquoise or stroke of chartreuse can bring luminosity and interest to an otherwise "beige" portrait.

Why should faces pose more of a challenge than inanimate objects? Consider that while a berry may be blue, it doesn't feel blue. Drawing tree bark, pottery or wicker are exercises in capturing texture and form. Having accomplished this, your work is done. However, texture and form are just the beginning when rendering the human face. You must also depict a specific, one-of-a-kind likeness while conveying a dimension that extends beyond the surface—that is, the subject's personality.

Did you mean to paint an arrogant stance? Or insecure slouch? Capturing such emotional nuances as "admiration" or "disdain" in your subject's expression can be tricky. Just a millimeter deviation in the slightest line can turn a smile into a sneer or make a perky subject appear drowsy.

Let's take the complexity of the portrait beyond its structural foundation. Let's add psychology. This element is especially central to self-portraits. Doing a self-portrait can be an eye-awakening experience filled with symbolism and introspection. There is a calculated thought process that reaches beyond aesthetic considerations in the selection of color, background, and pose. Each "prop" you include is relevant. The thickness and flow of each line defines your confidence and self-esteem. And sometimes there are surprises. Self-portraits are also a test in truth and honesty. Do I draw myself as I remember me, or as I now look. Do I give myself a graphic "nip and tuck," shave off five pounds, and remove that—what exactly is that? Do I portray that stranger in my mirror?

Self-portraits are intimate, visual diaries left open for all to see. As a discipline, artists interested in doing portraiture should do a self-portrait at least once a year. The honesty and perception we practice in learning to see ourselves extends to the depth, truth, and creativity we need to employ in portraying others. The ten artists in this section were invited to express their external image by looking from within.

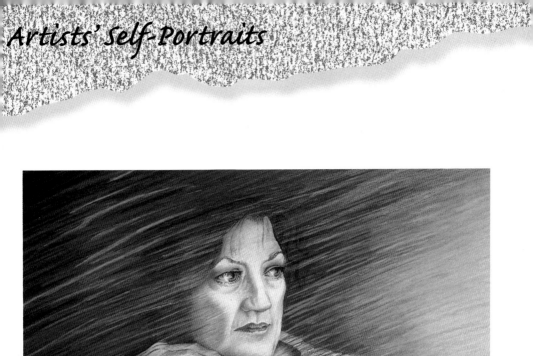

A NEW DIRECTION

12 x 15 in (31 x 438 cm)

Vera Curnow

With chemotherapy it was one long stretch of bad, or no, hair days. Since my tresses were still in transition, I decided to be noncommittal about a hairdo in this self-portrait.

PAST ISSUES – CANCELED SUBSCRIPTIONS

Vera Curnow

C ymbals, horns, bells and whistles. This self-portrait has all the subtlety of a Dixieland band. Assertive and brassy, it's a harmonic deluge of noise—to be absorbed all at once or one keynote at a time. Each detail, whether literal or symbolic, is instrumental to this tongue-in-cheek commentary on gender expectations and stereotypes—a subject I've been exposed to for half a century.

Using the graphic strategies employed by some magazine covers, this composition is a deliberate congestion of messages. The figures are portrayed as a cut-out photograph taken with multiple studio lights. As such, I used both linear and painterly applications. Hard edges define shapes, while the subject's form is modeled with color and value changes.

To distinguish the focal point in this wall of humanity, I placed myself a head higher than the mannequins and used the white masthead as a frame. This tonal mass of protoplasm would be boring, and confusing, if all the flesh tones were the same. I varied the skin shades with non-traditional hues in this mid- to low-key painting.

The compositional weight of this work is solid, balanced and impenetrable. Any breathing room left in this graphic editorial would be an interruption. There are no pockets of silence. There are no pauses. Just a steady drone. *Past Issues-Canceled Subscriptions* is a visual din made by one voice.

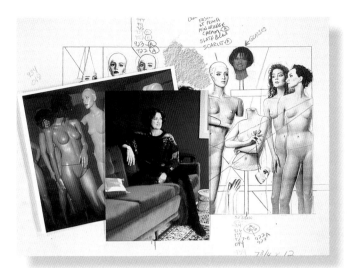

◀ *Reference materials included photographs and a collage made from mannequin catalogs. A slide of the collage was projected onto tracing paper, cut out and reassembled in the format shown, then drawn free-hand. A mirror and rose-colored glasses helped.*

PALETTE

HAIR

- Terra Cotta
- Scarlet Lake
- Pumpkin Orange
- Tuscan Red
- Deep Purple

SKIN

- Terra Cotta
- Burnt Ochre
- Orange Chrome
- Yellow Chartreuse
- Deco Pink
- Peach
- Tuscan Red
- Blush

EYES

- Dark Brown
- Deep Cadmium
- Warm Grey 90%
- Light Blue

SURFACE

100% Rag
 Watercolor Board

SUPPLIES

Soft Wax-based
 Colored Pencils
Hard Thin-line
 Colored Pencils
Colored Art Sticks
Electric Sharpener
Electric Eraser
Kneaded Eraser
Odorless Mineral
 Spirits
Bristle Brushes
 Nos. 2 and 3
Facial Tissue
Dried-out Ballpoint
 Pens (Medium and
 Fine Tip)
UV-Resistant
 Fixative

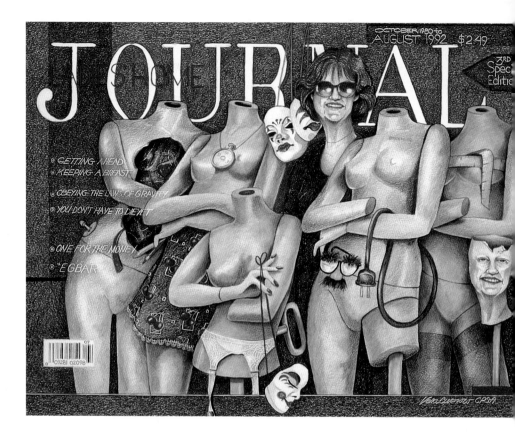

PAST ISSUES – CANCELED SUBSCRIPTIONS

17 x 22 in (43 x 56 cm)

Vera Curnow

More caricature than portrait, the goal of this illustration is to
communicate a philosophical statement rather than to document the
artist's appearance. Some will find this work unattractive. And that is
what it's all about—because, like many good people, good art should not
have to be pretty to be appreciated.

► *The skin tone on the left was created using bronze, celadon green, light blue, periwinkle, violet and cream. The one on the right is a mix of cool and warm colors. Burnishing was applied in selected areas only, letting the grain of the paper show through most of the work.*

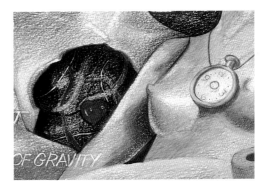

◄ *Impressed lines were made with dried-out ballpoint pens to create the fine-line designs in the apron and garter. Color was then applied over the etched lines, while retaining the white lines.*

► *The white of the large letters is the surface of the paper showing through. The thin letters are impressed lines with an inlay of red. The background is a mix of indigo, grape, black and violet.*

GALACTIC ODYSSEY

Marvin Triguba

No short-cuts, no compromises, and no surprises. Each painting is meticulously planned from the first stroke to the final signature. There is no guesswork or spontaneity once the work begins. After hundreds of commissioned portraits and a dozen self-portraits, Marvin Triguba follows a methodical sequence. Reference photos, preliminary sketches, color studies, and calculated measurements are just part of the process.

This complex composition of repeated imagery is nestled in a backdrop of pure black pencil—raw, dense and powerful. It would be faster and less tedious just to use a black surface. But it would also be less effective. In this painting, working on top of black would mute the light colors of the faces and give the heavy layers a pasty look. Rather than being influenced by the dark background, Marvin chooses a warm

sand colored surface to complement the flesh tones he will use. He knows that, once the faces and the hovering galaxy are completed, he must color around each starburst, each flickering light, until the paper's surface is invisible. He also knows that the effort is worth the results.

Hard edges are used to bring the subject forward, while lost borders in the clothing anchor the subject to its environment. This is important. Handled differently, the painting would look like "coloring-book style" heads floating on a flat field. Instead, the expanse of applied color that surrounds and infiltrates the subject adds depth and texture. The stark contrast dramatizes the illuminated faces and projects a glowing sense of awe in *Galactic Odyssey*.

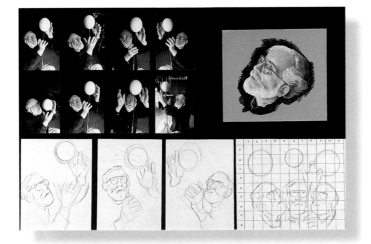

◄ Making photographs, pencil sketches, and a detailed color study, as well as laying out the composition on a grid are preliminary steps taken before the painting is begun. Reference materials on astronomy are used for accuracy.

PALETTE

HAIR

White

Warm Grey

French Grey

Light Umber

Dark Umber

Black

SKIN

Light Peach

Peach

Sienna Brown

Dark Umber

Pink Rose

Blush

Henna

Tuscan Red

Terra Cotta

Carmine Red

EYES

Black

Light Umber

Dark Umber

White

Terra Cotta

Sienna Brown

SURFACE

Canson Mi-Tientes
Paper, Sand #336

SUPPLIES

Wax-based Colored
Pencils
Mirror
Tracing Paper
Electric Sharpener
Electric Eraser
Kneaded Eraser
Workable Fixative

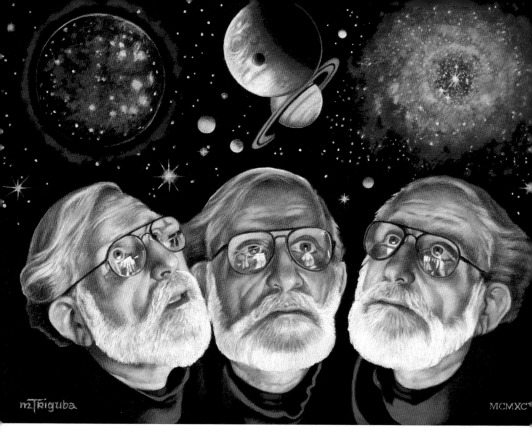

GALACTIC ODYSSEY

18 x 24 in (46 x 60 cm)

Marvin Triguba

Galactic Odyssey is the recurring theme in a series of self-portraits that began in 1972. It depicts a brief passage of time when life and death were inextricably integrated. For Marvin, this profound experience linked us to the beginning of time—microscopic elements in the universe—until, coming full circle, the energy of our lives are once again reduced to "star stuff."

► Neither the paper nor its color are an integral part of the painting, but merely serve as a receptacle for the pigment. The background, left for last, is densely covered with black colored pencil to obliterate the sand-colored paper. This adds a rich texture that black paper could not have provided.

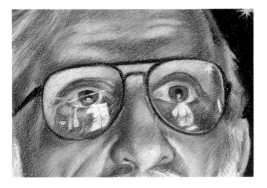

◄ The eyes are the only area where the colors are applied dark to light. For the flesh tones, light peach is first used for the highlights and the overall base color. Peach and sienna brown serve as midtones and are blended into the darkest values of terra cotta and dark umber. Pinks are added where the facial bones run closer to the surface (cheek, nose, ears, etc.)

► The hair ranges from white and grey to midtone raw umber and into a dark french grey. There is no need to define every strand. For a realistic look, the hair is rendered in sections—implying direction through the use of lights and darks. Notice the distinction between the texture of fine hair on the head and coarse hair in the beard.

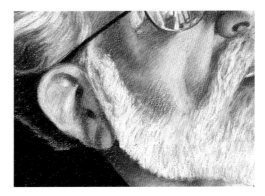

SPLASHBACK

Melissa Miller Nece

burnishing doesn't add more pigment or create wax bloom. For a pastel effect, she smears the color layers with a soft vinyl crayon-eraser. Using moderate pressure with either eraser, Melissa builds up a wax "slurry" of color on the tip so that she is pushing around more color than she is removing. Any excess can be lifted with a kneaded eraser or scraped with an artist's knife. Melissa also intensifies dark areas by burnishing with a paper stump, edge of a pencil top, popsicle stick or even a golf tee.

Splashback is an excellent example of what eraser blending can do—especially on a larger scale. Just by varying the strokes with, across, or against the paper's grain, Melissa creates or eliminates textures ranging from flesh and cloth to the splash, spray and flow of an ocean.

Three strokes and you're out! It doesn't take much to color saturate a one-inch face. There's hardly enough room to layer, mix, blend, and burnish—let alone create delicate value changes and capture a likeness. Working small doesn't necessarily produce the quickest results either. (Just ask any miniaturist.) Melissa Miller Nece decided to think big for this project—as big as 24x32 inches. This size allows her to control color and values, produce fine details, and to vary stroke applications. It also makes a sizeable impact.

Melissa's creative use of erasers reduces the tedium of mixing colors over a wide expanse. After applying several layers, she blends the colors and smooths the grain of the paper with an ink eraser pencil. This method of

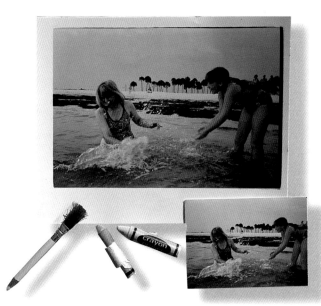

◄ *The artist works with an enlargement of the original photograph. Shown here are the ink-eraser pencil and crayon-erasers used.*

PALETTE

HAIR

Ultramarine

Dark Umber

Sienna Brown

Burnt Ochre

Yellow Ochre

Light Umber

Cream

Cerulean Blue

Jasmine

SKIN

Ultramarine

Light Cerulean Blue

Sienna Brown

Poppy Red

Peach

Light Peach

Salmon

Blush

Light Salmon

White

Cream

EYES

Ultramarine

Dark Umber

Sienna Brown

SURFACE

Smooth side of
 Canson
 Mi-Teintes, Cream

SUPPLIES

Wax-based Colored
 Pencils
Colored Art Sticks
Sharpeners: Battery,
 Electric and Hand
 held
Kneaded Eraser
Ink-eraser Pencil
Vinyl Crayon-eraser
Masking Tape (for
 lifting color)
Workable Fixative
Opaque Projector

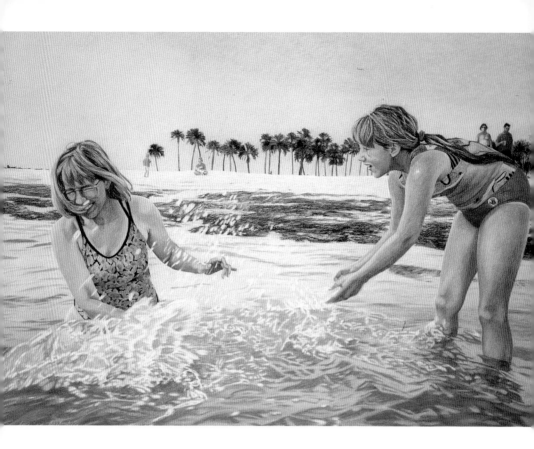

SPLASHBACK

24 x 32 in (61 x 81 cm)

Melissa Miller Nece

This "slice-of-life" portrait communicates the artist's close relationship with her daughter, Vicki. The large expanse of sky, in layers of light blues and white, is smoothed with heavy pressure from a crayon eraser. A kneaded eraser and white pencil are used to even the color and texture.

▶ *Caught in mid-action, the blurred facial details capture a sense of movement. This area is approached as a group of interrelated shapes—eraser blending, lifting and burnishing blend colors and values.*

◀ *The splash is just a pattern of light and dark shapes. Establishing the dark values first helps define the light areas. Middle tones are used to bring them together. Smaller white drops are retained by applying heavy pressure—this acts as a wax resist when applying other colors to the area.*

▶ *An out-of-focus rendering of the hands was created with soft edges to imply movement. Volume and form were created by gradating the values. Reflections of the sky's colors are included in the water's surface.*

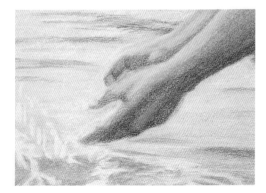

ABOUT ELEVEN

Cynthia Samul

L isten. Have you ever "heard" a painting? Some hum with the blended tones of somber shades—lulling and calm. Others move to a louder cadence of unmodulated hues. Stimulating. Refreshing. And then there are those that clash in a din of colliding colors to exhilarate and inspire—or assault and overwhelm—the senses. With literally hundreds of hues, tints, tones and shades available from colored pencil manufacturers, paintings can demand attention with a whisper or a roar. It is up to the artist to set the "volume"; and Cynthia Samul's visual voice is, by choice, very soft spoken.

If the science of color harmony is knowing which colors to use, then perhaps the art may be in knowing when not to use them. Cynthia effectively sets a time frame and mood with a limited palette of three colors: cream, light

umber and sepia. With a fine tonal application of several light layers, she uses these colors to create volume in her contour drawing. Light and dark areas are established first. The middle tone is then introduced to accentuate, subdue or blend these contrasts.

This painting is a masterful study of values and form. The spatial relationship of the geometric shapes is intricately organized—allowing the viewer to roam freely within the work. These seemingly random vertical and horizontal angles, however, are deliberate guides used to return attention to the focal point. The serenity of *About Eleven* is an audible statement that whispers the harmony of a quieter time.

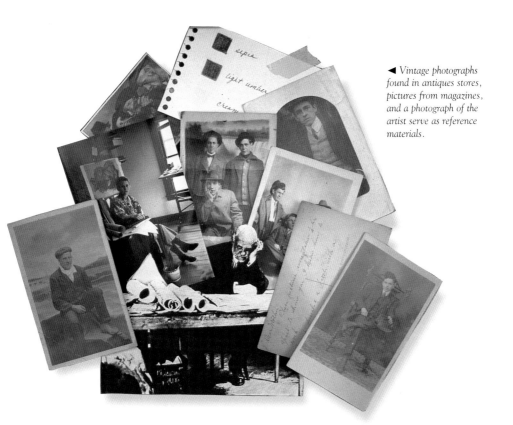

◀ *Vintage photographs found in antiques stores, pictures from magazines, and a photograph of the artist serve as reference materials.*

PALETTE

Cream

 Light Umber

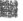 Sepia

SURFACE

Canson Mi-Tientes
 Paper, Sand #336

SUPPLIES

Opaque Projector
Wax-based Colored
 Pencils
Electric Sharpener
Mechanical Eraser
Erasing Shield
Workable Fixative

ABOUT ELEVEN

22 x 17 in (56 x 43 cm)

Cynthia Samul

Cynthia's penchant for art, reading and turn-of-the-century nostalgia is evident in *About Eleven*, which depicts the artist in her studio. While the painting is not supposed to be any particular period, an atmosphere of nostalgia was preserved by removing any items that were glaringly contemporary. The drawing on the easel was made from a photograph taken in a Depression-era soup kitchen. The placid atmosphere of the room and direct eye contact of the model give the viewer a sense of the artist.

► *Cream colored pencil, for highlights, light umber, for mid-tones, and sepia, for dark areas, were all lightly applied in various combinations. The surface of the paper was allowed to show through the layers to maintain unity and provide texture.*

◄ *Softly gradated values give three-dimensional form to the arm. Hard edges between the mid- and dark-tones are firmly blended—but not burnished— with several light layers. Notice how the lost edges—in the darkest shadows under the hand—lend depth to the area.*

► *Crisp fabric creases, thick wool stockings, soft leather, a hard wood floor, and the smoothness of a succulent plant are the varied textures captured with a tonal application of distinctive values.*

SELF-
EXPRESSION

Bernard Aime Poulin

E ver hear of the "Conveyor Belt Syndrome?" Two hundred and forty-two "originals"—all with the same pose and lighting—and done with the same paper, palette, and pencils in exactly the same technique, sequence and style, year after year. While working with a formula may save time, it hardly stimulates creativity or personal growth. And your originals now lack originality.

International portrait artist, Bernard Poulin, could certainly rest on his past successes—

never changing a thing—but, that's not in his artistic nature. While some artists don't experiment even in the privacy of their own studios; Bernard approached this book's project as he does all his work; with a fresh sense of exploration. Deviating from the realism he normally paints, he opted to do this self-portrait in a stylized combination of painting and drawing, and to do it on an entirely new surface. (If you're familiar with publishing deadlines, you know this is like working without a net.)

The clay-coated paper Bernard chose has the texture of a fine sandpaper. Its rough tooth rasps shards of pigment from the pencil, for making a thicker color application. So it takes fewer color layers—which means the palette must be planned in advance. Bernard adapts to the discoveries that present themselves as the work progresses. He finds that total color saturation on this surface is virtually impossible; therefore, the color and grain of this paper are always an integral part of the finished look. This paper lends itself to a loose style, since a fine tonal application is difficult to achieve on its surface. The soft pastel appearance of *Self-Expression* is an artist's sensitive portrayal of a dream come true.

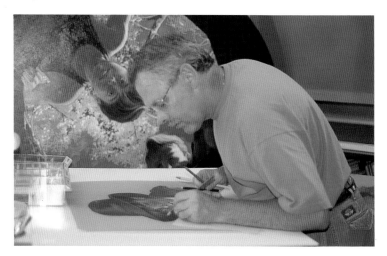

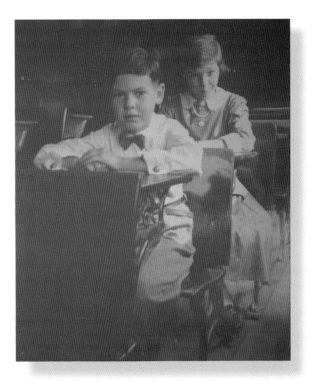

◄ *The artist referred to a mirror and this photograph of himself as a child.*

PALETTE

HAIR

 Dark Umber

Indigo Blue

White

Deco Blue

 Tuscan Red

SKIN

Tuscan Red

Light Peach

Peach

White

 Pale Vermillion

 Orange

 Lilac

EYES

Periwinkle

Sienna Brown

Dark Umber

White

SURFACE

Clay-coated Paper
 Olive

SUPPLIES

Wax-based Colored
 Pencils
Workable Fixative

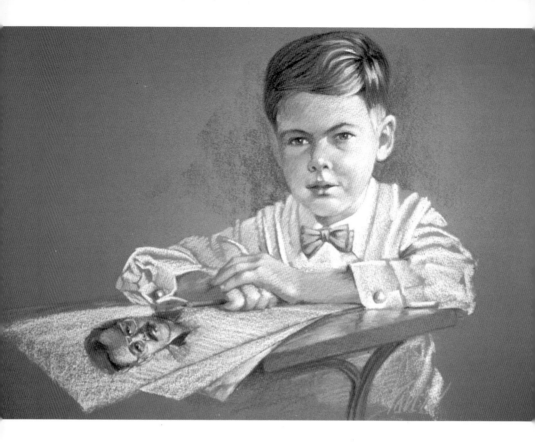

SELF-EXPRESSION

18 x 22 in (46 x 56 cm)

Bernard Aime Poulin

The painting shows the artist around the age when he first decided to become a portrait artist. He is shown as a child completing a portrait of himself as he looks today.

► *Warm tints, tones, and shades of red and orange are used over the cool, olive-colored paper. To capture the far-away look in the eyes, the right pupil was placed slightly off center and the highlight was tinted to reduce its intensity.*

◄ *While capturing the likeness of the adult, the sketch is deliberately kept flat to distinguish it from the three-dimensional reality of the child.*

► *The shirt cuff shows the sketchy, abstract shapes used to imply detail. The darkest shadows of the folds are the paper's surface. The results resemble a pastel painting, but the application is very different.*

SELF-PORTRAIT AS PAGAN FIRE GOD

Charles Richards

Lights, camera, action! What a four-star production. This self-portrait is a color and light show with a cast of thousands. With every inch of paper carefully scripted to emphasize the plot, Charles Richards fearlessly choreographs this barrage of activity and detail. Self-portraits are great springboards for unleashing the imagination: since they offer total control and an appreciative model, the artist can be miserly in dispensing personal information, can create another personae altogether, or can open doors on the darkest corners of the cranium.

What makes this ambitious painting work so well? Handled by less experienced artists, the end result could have been a tangled mass of chaos lost in a screaming collision of colors. However, Charles's precise use of design, color, and light eliminates confusion. He creates spatial relationships by placing vibrant contrasts of warm and cool colors next to each other. Strong light patterns give the illusion of three-dimensional form. Perspective, as in

the enlarged fists and foreshortened forearms, give the work a depth of field. Charles unifies the composition by placing repetitive patterns and colors around a dominant element. He varies the shapes and sizes to keep the work interesting—his sense of whimsical exaggeration makes it entertaining.

These factors work to keep this complex format readable. The viewer's eye enters this painting at the bottom, is drawn into its center and then led upward to the subject. There's certainly no doubt about the focal point— it's smack dab in the center. *Self-Portrait as Pagan Fire God* is ten tons of attention that no one will ignore.

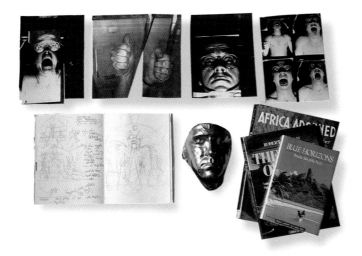

◄ *Photographs, photo-copy collages, initial sketches, painted face mask of the artist, King Kong video and library books are used for reference and inspiration.*

PALETTE

HAIR

Watercolor Wash

 Red Orange

Orange

Dark Purple

 Yellow Ochre

Mulberry

SKIN & EYES

Watercolor Wash

Yellow Ochre

Dark Green

White

Olive Bronze

Mediterranean Blue

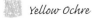 Blue Slate

(Approximately forty-five colors were used in this painting altogether.)

SURFACE

Arches Aquarelle
 Watercolor Paper
 140 lb. White

SUPPLIES

Watercolors
Wax-based Colored
 Pencils
Electric Sharpener
Workable Fixative
 (between layers
 and as a finish)

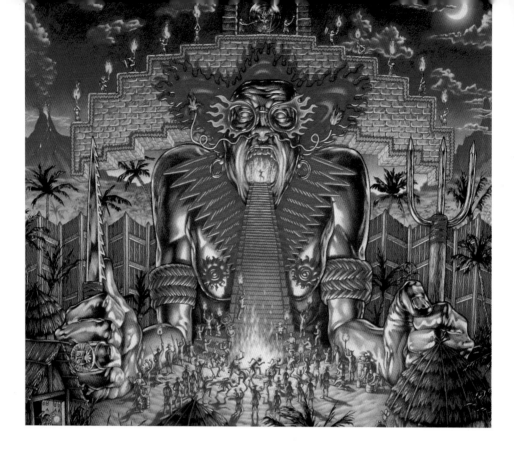

SELF-PORTRAIT AS PAGAN FIRE GOD

21 x 21 in (53 x 53 cm)

Charles Richards

The artist's "technicolor cartoon" shows his penchant toward the humorous, absurd or outrageous. He portrays himself as the idol and also as the small figure in the bottom left hut. This multilevel scenario is built on a primary focal point with secondary events scattered throughout its symmetrical composition. The painting started with a watercolor wash and ended with heavy colored pencil burnishing.

▶ *Dull areas are pulled forward by juxtaposing them with bright colors. Notice the furrows in the forehead. The distinct values and intense, luminous colors add to the theatrical lighting effect. Careful blending and color gradation create form—keeping the abstracted facial planes from looking like flat variegated fields of color.*

◀ *The same value range is used in both the light and shadow areas. The high contrast is created by color temperature— cool hues in reflected lights, warm hues in halftones next to highlights.*

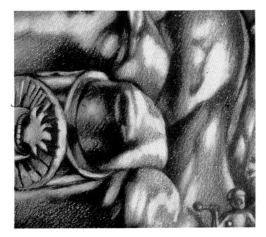

▶ *Colored pencils are applied over a watercolor underpainting of orange and violet. To avoid a coloring book appearance, white pencil is used to soften the edges of the fire and figures.*

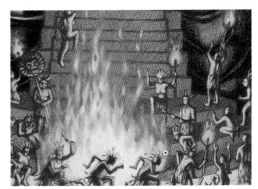

T he strength of this self-portrait is in its simplicity. Understatement. Subtlety. Ken Raney judiciously imparts information with a straightforward approach to design. The empty spaces carry as much weight as those that are occupied. What he chooses to omit is just as important as what he includes. This seemingly frugal rendering of sparse elements is actually a strong composition encompassing space, shape, color, value and line.

Ken's self-portrait provides a simplistic interpretation of the terms "colored pencil drawing" vs. "colored pencil painting." Here he uses both. Where shape, form and volume are defined by lines—as in parts of the shirt and rhino—we have a drawing. However, when they are created with color and value transitions—as in the face and hair—it is painting. Painting is the process of mixing and blending pigments to create various hues. It doesn't matter if these pigments are wet or dry or if they are applied with a brush or pencil or mixed on a palette or paper surface.

The power of the line is evident in Ken's work. To most colored pencil artists, lines are only guides to be obliterated. Ken's creative use of line is as relevant to the design, and to his message, as is his use of color. By leaving portions of his contour drawing exposed, he emphasizes the dichotomy between the real and the imaginary. Three-dimensional form emerges from the flatness of the surrounding schematic to create *Self-Portrait with Dino*.

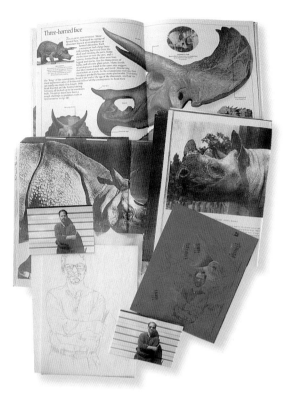

◄ *References of a dinosaur and rhinoceros, photographs of the artist with and without glasses, pencil sketch and rough color study were used.*

PALETTE

HAIR

White

Cream

Canary Yellow

Burnt Ochre

Sepia

Indigo

SKIN & EYES

Cloud Blue

Cream

White

Canary Yellow

Pale Vermillion

Orange

Lilac

Clay Rose

Imperial Violet

SURFACE

Canson Mi-Teintes
 Sand-Smooth Side

SUPPLIES

Wax-based Color
 Pencils
Airbrush
Electric Sharpener
Ink
Workable Fixative
Acrylic Mat
 Medium

SELF-PORTRAIT
WITH DINO

14 x 12 in (36 x 31 cm)

Ken Raney

Ken Raney has combined his experience as a graphic designer and children's book author and illustrator in *Self-Portrait with Dino*. Both of his books feature dinosaurs. The absence of peripheral information keeps the viewer focused on the main subject.

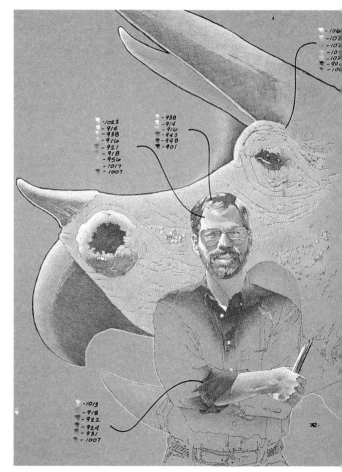

▶ *Two photocopies of the initial drawing are made on Canson Mi-Teintes paper. One copy is reduced to half size and used for making a rough color study. The other, full-size copy is sprayed with workable fixative and used for the finished artwork.*

◀ *Color is applied with tight cross-hatching, leaving the contour drawing beneath visible. When the color work is completed, the entire surface is sprayed with an airbrush using a 50/50 mix of acrylic mat medium and water. This seals the work and creates a new surface for additional color.*

▶ *Color notations, made with ink, are incorporated as part of the composition. Every design element is made to emphasize the focal point.*

SELF-PORTRAIT WITH LIFE MASK

Susan Avishai

Linear, scribbled, firm and soft. These are just some of the strokes you might find in Susan Avishai's colored pencil paintings. Many artists, dedicated to one method of laying down color, use the same application in all their work. Susan, however, freely changes the characteristics of her strokes within a painting. Much like an orchestra leader feels the music with the wave of a baton, Susan uses the colored pencil to experience the surface she is trying to create. A light brush of the pencil softly colors the cheek. The movement of a curved stroke mimics the rhythm of the hair. And short, rough jabs of color help define and texture the hardened gauze mask.

Susan moves around the painting never fully completing one section before another. She establishes dark areas while also building middle tones and lights—leaving room to push the shadows darker and the highlights lighter. Dark areas are eventually saturated with dense layers of color. By working on grey paper, Susan is able to use white as a color to model the sculptural dimensions of the mask.

This is a bold composition. Warm colors, smooth textures and black shadows frame the cool, coarse whiteness of the mask. The compositional weight of the strong elements are evenly distributed. Both the face and the mask project toward the viewer in a compelling way as they emerge from the dark background. A little mysterious, a little unsettling, *Self-Portrait with Life Mask* is very effective.

◄ *Photographs and a plaster mold of the artist's face serve as reference materials. An opaque projector was used to transfer the photograph to the drawing surface.*

PALETTE

HAIR

- Terra Cotta
- Dark Brown
- Burnt Umber
- Black
- Yellow Ochre
- Cocoa
- Light Coffee

SKIN

- Deco Orange
- Rosy Beige

- White
- Flesh
- Salmon Pink
- Sand
- Clay Rose
- Sienna Brown
- Light Peach
- Burnt Ochre
- Burnt Peach
- Terra Cotta
- Light Coffee
- Pink

- Deep Pink
- Cocoa
- Dark Brown
- Raw Umber
- French Grey 10%

EYES

- Raw Umber
- Sienna Brown
- Burnt Ochre
- Yellow Ochre
- Black

SURFACE

Grey BFK Rives
 100% Rag Paper

SUPPLIES

Mirror
Opaque Projector
Wax-based Colored
 Pencils
Water-Soluble
 Colored Pencils
Electric Sharpener
Mat Fixative

- White
- Dark Brown
- Dark Cold Grey

SELF-PORTRAIT WITH LIFE MASK

13 x 10 in (33 x 25 cm)

Susan Avishai

Self-Portrait with Life Mask focuses on an artist's strongest tools—the hand and eyes. Preferring to be the agent of the picture rather than its subject, Susan gives the viewer limited information by juxtaposing the mask and face. Working with metaphors, she confronts mid-life by taking the risk to slowly expose her true self. The viewer must rely on the mask's facade to get the full picture of the artist's appearance.

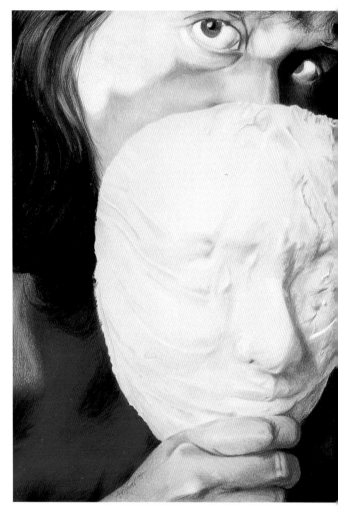

▶ Halftones are used to bridge the transition between shadow and light areas. The deep shadow in the face loses its edge as it blends into the dark background. This provides three-dimensional depth, while the hard edge between the mask and shadowed area bring the mask to the foreground.

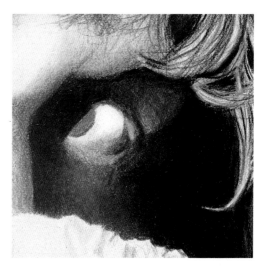

◀ The grey surface of the paper, along with a limited palette of white, french grey, marine green, and raw umber, help define the sculptural dimensions of the mask. Linear strokes left visible in the shadows give the gauze mask a coarse texture.

▶ Shapes of lights, halftones, and shadows define the facial planes. The movement of the hair is formed in sections rather than individual strands.

"NOW, WHAT THE HELL…?"

Robert Zavala

"Where did you get that idea?" Artists are always asked this question. If the answer is known at all, it's rarely a simple one. Sometimes the creative process is so convoluted that it's difficult to trace its origin. The answer to "how did you produce that idea?" might be just as interesting. What lay people are not aware of is the preparation that goes into the simplest concepts. Before pencil touches paper, Robert Zavala consumes many hours with preliminary research, sketches, reference materials and even some theatrics.

Robert physically constructed this mental image. With the help of his family, he sets up props and lighting in his studio to photograph the posed "characters." Robert cuts and arranges these photos into a workable composite from which he makes a black and white drawing. This drawing serves as a value study and is the base for the actual work. He reduces it in a photocopier so the image will fit into an opaque projector and then traces it onto the mat board. It isn't until many days later that he can begin painting.

Like most artists, Robert finds that no matter how many preliminary steps are taken, the work in progress develops a voice of its own—dictating additions, deletions, adjustments and sometimes, as in this case, even a "Plan B." Halfway into the work, Robert finds a thin razor cut in the mat board—starting almost from the top and running down to the drafting table. As color layers were built up, the cut became apparent. This prompted the decision to add the block wall for camouflage. The smaller drawing on the table was drawn using the cut as one side of the square (look closely). The demon muse lurking behind Robert Zavala for so many years probably whispered this solution to him in *"Now, What the Hell…?"*

◀ A composite of several photographs is used to develop the composition.

PALETTE

HAIR (Robert)

▦ Black

▦ Pumpkin Orange

▦ Dahlia Purple

White

HAIR (Demon)

▦ Green

▦ Black

White

Lemon Yellow

▦ Dahlia Purple

SKIN (Robert)

▦ Terra Cotta

Cream

▦ Pumpkin Orange

▦ Vermillion Red

▦ Purple

SKIN (Demon)

▦ Green

Lemon Yellow

▦ Black

White

▦ Purple

EYES

▦ Black

White

SURFACE

White Crescent Mat Board, Smooth Finish

SUPPLIES

Wax-based Colored Pencils
Watercolor
Electric Sharpener
Gum Eraser
Pink Pencil Eraser
Electric Eraser
Workable Fixative

"NOW, WHAT THE HELL…?"

16 x 13 in (41 x 33 cm)

Robert Zavala

The artist reduces distraction by cutting a 4" x 4" square out of
a white piece of paper and laying it over the area to be
worked until that section has been completed. The idea for
this self-portrait was many years in the making.

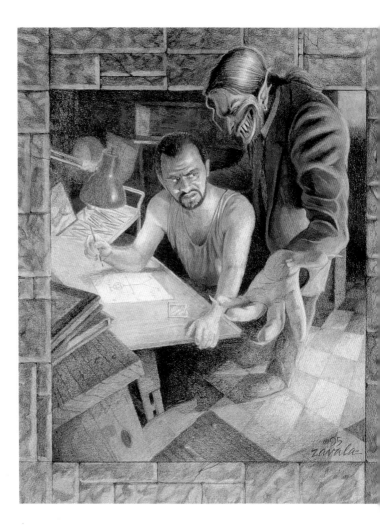

► *After a black and white underpainting is established, two coats of workable fixative are sprayed. A hair blower is used to dry each layer before any colors are added. The artist works in one of his favorite color schemes—using lots of purples and oranges.*

◄ *Once the color layers are completed on the stone border, a very light watercolor wash of sienna brown and yellow ochre is applied to tone down the purple. Notice the grainy texture of the wall next to the burnished smoothness of the shirt.*

► *The forward projection of the hand is created by exaggerating its size, using a contrasting color, foreshortening the forearm and placing it over a dark shadowed background.*

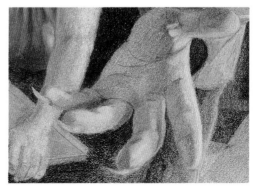

"WHAT WAS THAT?"

Charles Demorat

Three easy steps. Black, color and white. That's all it takes to create this tonal application. However, these three steps can take anywhere from 40 to 130 hours to complete. While Charles Demorat views this as a meditative process, he doesn't recommend it for those in a hurry. The operative word is "patience."

The first step is the "heart" of the entire painting. With the lightest possible touch, Charles uses a hard black pencil to create a monochromatic underpainting, called a grisaille (greez-eye). Grisaille establishes the value patterns in the work and creates three-dimensional form. This is done by s.l.o.w.l.y. building thin layers of pigment using a very sharp pencil. This is important. Charles sharpens the pencil every thirty seconds. He continues layering with black until the darkest values are fully developed. This stage is now done. The middle values are the paper's colored surface, and the lightest values will be added later. The painting is lightly sprayed with workable fixative and allowed to dry.

In Step 2, Charles lightly blends color over the grisaille—being careful not to obliterate the drawing beneath it. Once all the colors are applied, another light coat of fixative keeps them from smearing. Step 3 brings his self-portrait to life. Charles adds white highlights to make selected areas "pop" forward. One last spray of fixative completes the process. The eerie underlighting creates a wonderful tension that is contrary to the delicate tonal application used in *"What Was That?"*

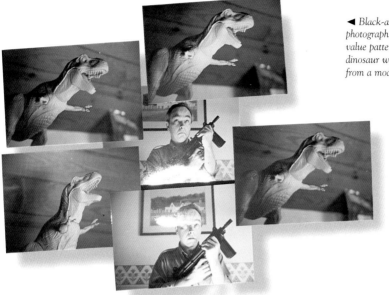

◀ *Black-and-white photographs show the value patterns. The dinosaur was assembled from a model kit.*

PALETTE

HAIR

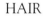 Raw Umber

Burnt Umber

Yellow Ochre

Indigo Blue

SKIN

Salmon

Light Flesh

Blush

Cream

Orange

Holland Blue

EYES

Yellow Ochre

Raw Umber

Olive Green

White

SURFACE

Canson Paper
 Felt Gray

SUPPLIES

Wax-based Colored
 Pencils (Colorease
 Brand Black
 Pencil)
Opaque Projector
Electric Sharpeners
Kneaded Eraser
#11 Artists' Knife
Workable Fixative
 (between steps and
 as a finish)

"WHAT WAS THAT?"

16 x 13 in (41 x 33 cm)

Charles Demorat

The artist's self-portrait shows him as the "mighty hunter"—although that's not a role he plays in real life. (The menacing weapon is actually a water gun. His message: "Be careful what you look for, it may be two steps behind you—and higher on the food-chain."

▶ A kneaded eraser lifts color from highlight areas. In tighter spaces, like the corner of the eye and the thickness of the eyelids, an artists' knife is used to remove color.

◀ The values in this low-key work are built dark to light. The distinct value range and the subtle gradations create volume and form.

▶ The entire painting is done with small circular motions applied with a consistent light pressure. The soft tonal application leaves no visible strokes and resembles a fine powder.

DIRECTORY
OF
ARTISTS

SHERI LYNN BOYER DOTY

2801 S. 2700 East
Salt Lake City UT 84109
801-467-6013
801-582-2716

AMY V. LINDENBERGER

Linden Tree Fine Art Studio
825 East Maple Street
North Canton OH 44720
216-494-8951

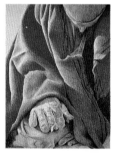

SUSAN AVISHAI

28 Marlboro Street
Newton MA 02158
617-969-5451

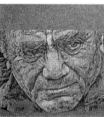

SORY MAROCCHI

5017 N. Shoreland Avenue
Whitefish Bay WI
53217-5540
414-964-6562

VERA CURNOW, CPSA

The Electric Pencil Co.
1620 Melrose #301
Seattle WA 98122-2057
206-622-8661
206-622-2228 Fax

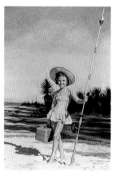

MELISSA MILLER NECE, CPSA

2245-D Alden Lane
Palm Harbor FL 34683-2533
813-786-1396

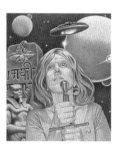

CHARLES DEMORAT

305 Cornelia Drive
Graham NC 27253
910-229-7359

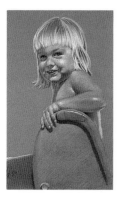

BERNARD AIME POULIN

Bernard Poulin Studios
100 Pretoria
Ottawa Canada K1S 1W9
613-130-8177
613-233-3433 Fax

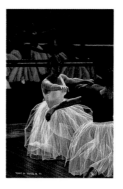

THOMAS M. THAYER, JR.

P.O. Box 5246
Lynnwood WA 98037
206-778-2988

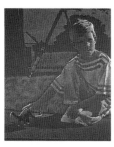

KEN RANEY

433 S. Ridge Road
Hesston KS 67062
316-327-2669

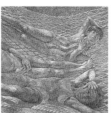

MAGGIE TOOLE

3655 Colonial Avenue
Los Angeles CA 90066
310-398-4587

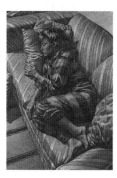

CHUCK RICHARDS

The Art Department
5101 Evergreen Road
Dearborn MI 48128
313-845-6486

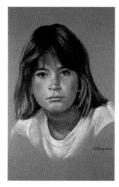

MARVIN TRIGUBA

House of Triguba
1463 Rainbow Dr. NE
Lancaster OH 43130
614-687-1338

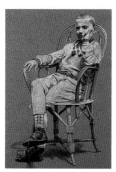

CYNTHIA SAMUL

15 Pacific Street
New London CT 06320
203-444-7060
203-442-5695

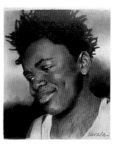

ROBERT ZAVALA

695 Old Beaumont Highway
Silsbee TX 77656
409-385-0225